NO EXCUSES

by

Desmond Earl Bryant White

No Excuses 1

No Excuses 3

TABLE OF CONTENT

EXCUSE-LESS
MEETING MYSELF
KINKY THOUGHTS
UNIVERSAL PRAYER
SEARCHING
ALARM CLOCK
RUNAWAY SLAVE
MONEY MOVES
MOMENT UM…
UNBELVABLE TRUTH
SCHOOL DAYS
UNIQUE
SHINE
TOGETHR
DYING BREED
CASINO LOVE
RARE
BORN SINNER
SURVIVAL
UNREPAIRABLE
HARD TIMES
CAPTIVE PRAYER
DAYDREAM
BASE ROCK
H.E.R.

"Be STRONGER than your

STRONGEST EXCUSE."

Excuse-less

Life is about what you invest

after all your bills are paid.

Nobody stressing but me

over the moves I have made.

Despite misfortunes,

we fight for our fortune.

Ever been broke before?

The closest feeling to torture.

Like a summer day no air

conditioned for the heat

it was a scorcher.

White fans propped

inside the window.

Perfectly fitting

like a piece to a puzzle.

Blame the maybes

A constant flow of

progression,

A steady effort, persistence,

hustle and ambition.

If you don't use it,

you might lose it.

Make a way through it,

No Excuses.

No Excuses.

No Excuses.

My Thoughts

"You have to LEARN to LOVE YOURSELF before you can LOVE SOMEONE ELSE. It is ONLY when we LOVE OURSELVES that can feel WORTHY of anybody's LOVE.

Meeting Myself

Hi, I waive from a distance

Hi, I know you, right?

I know who you are.

Hi haven't I seen you before?

I know what you have done.

Know where you have been.

Know what you have seen.

I know what you fear.

I know what you dream.

We are the same.

No "I" in team.

Without you,

there is no me.

You are my insecurities.

The moment when

I was looking.

Into a pair of confused eyes.

At that moment I realize I

was looking into mine.

My Thoughts

"HAIR is a BEAUTIFUL form of SELF-EXPRESSION."

Kinky Thoughts

Remove the kinks

from your mind

Not the kinks

from your hair.

A reminder that your

ancestors were

murdered unfair.

A sign they were once alive

and well right here.

A reminder of your great

grandmother's,

who didn't survive

the trip here.

Just imagine the

Atlantic's humidity.

Before Gabby won gold

and sweated out her edges.

A prestigious medal

for America to wear.

Them summer days our

Ancestors were forced off

Of the ship's ledges.

Harriet Tubman

freed many

from the cold chains

they bear.

Sometimes looking in the

past what happened

seems to be unfair.

We send our prayers

to the clouds

but I guess no one was there.

In search of God,

our hair grows in the

direction of the sun.

In search the energy

The inner "G".

The inner me.

In search of the stars,

a constellation is forming.

A pattern spiritually,

it's more like a journey.

Take a breath, calm down.

Don't be so much in hurry.

Remember to Love your mirroring image.

No matter how much the reflection is blurry.

My Thoughts

"FORGET the THREE powerful RESOUCES you always have available to you: LOVE, PRAYER and FORGIVENESS."

Universal Prayer

I pray for good health.

I pray for ambition,

I pray for the strength

To be the most with what

was given.

Sometimes I wake up,

no energy, I feel weak

Aware nothing was given.

Everything

can be taken.

So, I say thank you

and remain humble.

Forever,

indebted and grateful.

I pray for the less fortunate.

To obtain great wealth.

I pray for my family more than I do anything else.

I pray for others more than I do for myself.

Say less who you pray to.

Your right to worship,

according to our own faith

and religion.

Some don't believe.

Until it is time to grieve.

Is there a heaven and a hell?

Look in the Sky

Or beneath

your feet.

One must look from within.

To find who their soul meets.

I pray to the one inside.

Where I find my Inner G.

Where I find my Energy.

Intuition, Intelligence.

Ignorance.

That moment when you

knew it was wrong

and you chose to go against

your gut feeling.

When you did what

was felt right.

In return you

lost a great dealing.

Prayer,

Meditation,

Third Eye Open.

To be in touch with

my higher calling.

When you are

protected by God.

You never have to worry

about falling.

My Thoughts

"It's during our darkest moments that we must focus to see the light."

Searching

Sleep is the cousin of death,

Waking up is

the cousin of life.

After a fight,

how much love is left?

After a fight,

does it matter who is right?

The blame games.

Saying the same thang.

Although the pain is stained,

It is deeply engrained.

Despite all the darkness.

Still I search for the light

My sights are focused.

My destiny is

deeply engraved.

My soul is saved;

my mind enslaved.

Looking for a new path.

Looking for a new light.

Looking for something real,

In a crazy life.

My Thoughts

"With every new DAY comes new STREGNTH and new THOUGHT."

Alarm Clock

Beep!!!

Beep!!!

Beep!!!

Staring at the ceiling

as the alarm clock rings.

Mentally preparing myself

for whatever the day brings.

Simultaneously I feel guilty

because I went to

sleep broke.

However, money

doesn't fulfill me.

It's hard to remain woke.

Waking those pretending to

be sleep.

They say success comes to

those who wait.

Nothing came to a still me.

Sometimes the body

Needs more sleep

All that is received

is a daydream.

Prepared for whatever the

day brings.

I roll over and the other half

of my team is still sleep.

One of the most beautiful

sights that I will see.

Expand my mind

like Socrates.

Plans to build houses on

several different properties.

With jail around every

corner, real life monopoly

400 years late entering

into this game.

People sell they souls in

order to gain fame.

Not feeling any shame,

Looking at who to blame.

Let me find out you went to

jail just to meet a plug,

Let me find out you had a

baby just to keep a thug.

Let me find out

you lost the rent money

shooting dice

on a dirty rug.

Let me find out

you went to the club

looking for love.

Ambitious,

but I've hit the snooze button

like five times already.

Let me go ahead and get up,

I didn't have time yesterday

but today I'm ready!

My Thoughts

"It's not HARD to make

DECISIONS when

you know what your VALUES

are."

The Runaway Slave

If I were a slave.

Would I stay,

or would I run?

Would I slack off

in the shade?

Complexion darkens

in the sun.

It's hot out in the streets

hard to take the heat.

protects my skin

from the burn.

They say if you're not guilty,

Then why did you run?

Maybe it's done for fun

or because they have

a badge and a gun.

Flaming dots

walk into the light.

A connection

that will claim a life.

Bullets do not have names.

They shoot for the stars.

It's strange to explain.

How the youth

want to gang bang

Fighting over hoods

they claim but don't own

a thang, what a shame.

I can't push the blame,

It's a cold world,

a crazy game,

and they are not playing fair.

That's why I run,

just a runaway slave

trying to get away.

My Thoughts

ANYTHING is POSSIBLE

with a DOLLAR

and a DREAM."

Money Moves

I know 100 ways

to get 100 dollars

in under 100 seconds.

Never had a plug

yet I stay connected.

Hate received,

but I'm not effected.

Learning from mistakes,

I've been tested.

Bob Marley resurrected.

Rise above the hatred.

Respect is expected,

too many neglected

It's rough in this world

when times get hectic.

If I must have

my pistol with me,

then I probably

shouldn't go there.

If that is the case.

It's crazy!

cause then I would

probably go nowhere.

I am Brave

but fear made me aware.

That is 5 generations

of oppression,

For those that care,

this is wisdom.

Hire an out of town lawyer,

never a public defender.

fending for myself.

When I didn't

have a dollar

that is when

you will find yourself.

Looking for happiness

searching for great wealth.

Looking for happiness?

search first inside yourself!

My Thoughts

"One way to keep moving FORWARD is to have CONSTANLY greater goals."

Moment um...

Looking at what is left,

Wide awake.

Eyes open daydreaming.

Contemplating

on what is right

mind steady scheming.

Wasting money,

wasted time.

Wasted minds,

wanting to shine.

I hate waiting,

skipping lines.

If I don't own it,

It's not mine.

Consistency is key,

Steady Grind.

Reality is tough to face,

Skipping time.

First you must believe it

and then you will see it.

You want it?

Then go out and get it.

It's an easy choice

take it or leave it.

Your dreams won't grow legs

they won't walk to you.

If you only knew

God already gave

his life for you.

You ever felt like the wind

is speaking to you

That is intuition

you are feeling,

It tells you what not to do.

We often hear it but don't

listen like the advice given

don't apply to you.

They thought they knew

but they didn't really know

what's true.

Just let people

be who they are

and eventually they will

reveal to you.

We look at television

for the truth.

Seeing is believing.

When I was young,

I was told I was ugly,

and for a long time,

I really believed it.

Sometimes I feel like we

focus too much

on who we were,

not enough on who we are.

If you wanna be great.

It's your job to set the bar.

My Thoughts

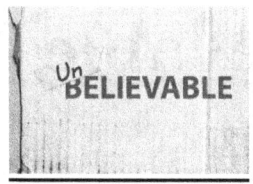

"NEVER BE AFRAID to fall apart because it is an OPPORTUNITY to REBUILD yourself the way you WISH you had been all along."

Unbelievable Truths

If they knew the truth,

Maybe they would not judge.

What may be the truth

for them.

Is not be the truth for us.

What some consider

a windstorm.

Other consider a small gust.

What is the truth?

Who is the real judge?

Backing me up against

a wall off knives.

Sharpened by the rocks

thrown at my flaws.

Don't push me against

these deadly lies.

They are convicting

with these dirty laws.

Believe the unbelievable.

Achieve the unachievable.

My Thoughts

"I spent my CHILDHOOD wishing I were OLDER and now I'm spending my ADULTHOOD wishing I were YOUNGER."

School Days

I wish I were a kid again,

climbing trees

playing on the jungle gym.

Wearing Velcro on my shoes

With no laces.

I wish I were a kid again,

I wished I could pick a child

and trade places.

Hanging with your friends

Remembering all the

neighborhood races.

Playing hide and go seek.

Eeny, meenie, Minnie, moe catch a Tiger by his toe if he hollers let him go.

Eeny, meenie, Minnie, moe.

My momma said that you

are the very best one

and… you…

are… not…

it…

Remember how

the worst problem

was scraped knee's

and runny noses?

If you go outside,

you stay outside

once the door closes,

it closes.

You wanted to grow up

and have freedom,

like parents who needs them.

Time went by as you were

getting older.

Constantly getting

the cold shoulder.

You hit your teenage years

and you were finally grown.

If I were a kid again.

I would appreciate school.

Convinced that learning

was not cool.

Back when I had no

responsibilities.

As an adult seems

all I do is work.

When I was a kid,

I grew up in a household

where my mother was

always drunk.

She would get all friends

together to party

I can never forget the

alcoholic funk.

Blues music playing through

the speaker.

I loved the music.

It's like it spoke to my soul.

I would dance away

my worries.

Running man,

to escape reality in a hurry.

My Thoughts

"Celebrate the idea that

ARE DIFFERENT

Find your own FIT.

Be YOURSELF.

UNAPOLOGETICALLY."

Unique

Afraid to get to close,

Scared they might bite.

If you touch me,

we gone fight.

It's amazing how
some people
value the life of their dog
more than they value mine.
Everyday babies are born
they don't make them like
me anymore.

I'm cut from a

different clothe.

Limited Edition.

They don't make

this fabric anymore.

This new age generation

are made up like napkins,

A moist one that's

been jacked in.

Integrity, morals,

values lacking.

Lying is like acting.

Trying to portray a character

in which they are not.

They say they are

whipping the rock,

but really, they not.

Boiling water just to drop

roman noodles in a hot pot.

My aura shines through the

cloud of crack smoke.

I have never sold drugs

the bag I have is organic.

White rock affected my life

it's crazy how quickly things

can appear

and then they vanished.

Jumped off the porch early

we here bred to be mannish.

Stuck in between

a rock in a hard place

oppression in my face.

Ball and chain on my ankles,

feels like a rigged race.

It is a marathon not a sprint,

But I play for first place.

The game is not fair,

I feel cheated.

Stay focused on

your plans and goals

and never be defeated.

My Thoughts

"It takes nothing to JOIN the crowd. It takes everything to STAND alone."

Reflection

In my mouth

Lies this bad taste.

I thought I was winning

turns out I'm stuck

in last place.

My head spinning.

Feeling overused like those

red one hundred emoji.

It was a point in life

I loved being

in the spotlight.

It seemed like

wherever I went.

I pack of groupies

seem to follow.

I was on my high horse

I was the man riding on

the Ralph Lauren Polo.

My horse had wings and

could do amazing things.

Introvert, Isolated

all these people around me

I enjoy being solo.

I am aware

it is rare.

I have a good heart

that's scarce.

The suspense is killing.

A mystery, no ending.

My Thoughts

"STUCK in a generation where LOYALTY is just a tattoo, LOVE is just a quote, & lying is the new TRUTH."

Minimal Millennial

Call me old fashion

but I take love, sex and

feeling seriously.

I mean when I love,

I give it my all.

Each stroke

performed eagerly.

Is applied with

precise pressure.

Each breathe

is inhaled deeply.

Each I love you said clearly,

lately it is lesser.

She is missed ever so dearly

Women scared to love

Men scared to show

emotion.

It is not the size of the boat

It's the motion in the ocean.

Every kiss is golden.

Every touch is token.

When we are together,

I enjoy every moment.

When I look in her eyes,

She has my complete focus.

I'd like to report a crime,

My heart has been stolen.

My Thoughts

"Be THANKFUL for all you that you have and where you are in LIFE because this time next year, NOTHING will be the SAME."

__Rare__

If you correct your mind,

everything else will

fall into place.

With hopes that my kids

will see me be great.

Planting seeds

that will grow strong.

Provide shade I may never

get to lay in.

Creating sparks in

Children's imagination

We all were born a baby

and we will all die

eventually.

Life repeats itself,

it has an echo.

Are there any blessings

for felons?

Do all dogs go to heaven?

I wonder if heaven

got a ghetto.

The line is long,

the gates are narrow.

Praying through

the hard nights

Tomorrow things will

get a little better.

My Thoughts

"They say that LOVE is more important than MONEY, but have you ever tried to PAY bills with a HUG?"

Casino Love

They say life's a gamble.

Love is a casino,

I'm all in at once.

I should of peeped the scene.

Sometimes we stick our money in without really knowing the machine.

Disappointed and confused

cause things weren't what

they seem.

It took everything you had

now you're looking to

redeem.

It is enticing,

the lights are attractive

the bells are appealing.

That adrenalin rush when

you cash out,

now that's

a wonderful feeling.

But with no windows

It is easy

to lose track of time.

Playing the odds

trying to court lady luck and

make her mine.

You ever lost it all

And didn't have enough

for the toll?

Tring to win back your losses

on the next flip or roll.

The Dealer said eleven

and forced you

to double down.

The dealer turns twenty-one

now you are stuck

with a frown.

Hours in this building

hoping wishing

and praying to win a lot.

But If I do end up going

I'm only taking 40 dollars

and hope I hit the Jackpot!

My Thoughts

"The ONE thing that you have that nobody else has is YOU. You voice, your MIND, your STORY and your VISION.

Familiar Stranger

I feel like

an Endangered species,

there only a few of my kind.

It's not even what is seen,

it's the things that go on in

my mind.

Observing from a distance.

Discovering my existence.

No longer enslaved,

what is freedom.

Feeling caged inside

like a prison.

Diminished vision

why speak when no one

is listening.

I have been lied to.

I've been tied.

my shoulders been cried on

and I have cried.

But my eyes dried

anytime I discovered

somebody lied.

I am not surprised.

Stay true to yourself

Never compromise.

My Thoughts

"Sometimes, GOOD PEOPLE make BAD CHOICES. It doesn't MEAN that they are BAD. It means they are HUMAN."

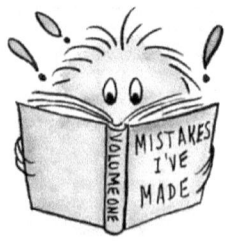

Born Sinners

Many situations, I've been

taken advantage of.

I don't judge others,

I know that we were

probably raised different.

I've been a follower.

It is better to be a leader.

Cut deep like a razor

pissed off, releasing anger.

That is better than being

pissed on by a stranger

Intentions with a mission.

Precision like a laser.

Born to make mistakes.

That is why pencils come

with erasers.

My Thoughts

"If you don't VALUE your time, neither will others. STOP giving away your time and talent. Value what you know and START charging for it."

Survival

Gods biggest gift is being

born on this earth.

I ask

how much a soul is worth?

Is being Black its own curse?

Riding down the north side

with a .38 revolver.

Rather get caught with it

than without it.

My thought process

was the problem,

Too ignorant to solve.

I should have had my head

in the books.

I should have been studying

for the test.

I guess that it is true what

they say.

I was steady plotting on the

next liq.

There aren't no such thing as

halfway crooks.

There is no in between.

Either you out or your all in.

It is not until things get bad.

When you find out who is

really a true friend.

My Thoughts

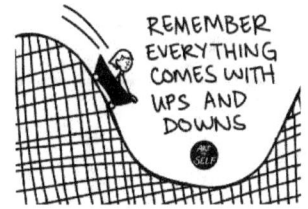

"I think the HIGHEST points and the LOWEST points are the most IMPORTANT. Everything else is IN BETWEEN."

Unrepairable

There is no way

I was born just

to work and pay bills.

Every time I pay rent,

Stomach hurts, I get chills.

Like the ice water challenge

it is an unwanted thrill.

When I have money,

I have nothing to buy.

When I don't have money,

Everything catches my eye.

Often there are things

that money can't buy.

Is money the root of all evil?

Or is it Greed the seed?

When being free was illegal

Jealousy thrives,

through envy it feeds.

They say money

can't buy happiness

and the best things

in life are free.

So free my people,

give them praise for the

blood, sweat and tears.

Their sacrifices

Idolize their bravery.

Free my people

from bondage,

centuries of mental slavery.

Never broken,

All they had was faith.

Something no one can take

from you.

Some people are so poor,

all they have is money.

It's funny

how people change

once they get a little money.

I wish people were like cash.

Hold them up to the light to

see if they are real.

I never made a dollar

that made me feel

the way people once made

me feel.

People will judge solely off

what you have.

People will talk

behind your back.

Before they even have

the courage to ask.

People call what they don't

understand weird.

I'm not here to impress.

I here to be a better man.

Whoever said money don't

buy happiness,

Deposit in my bank account

what you can.

In the end it's just your turn

it not really yours

it is just an illusion.

Things happen for reason.

You live, and you learn,

the confusion.

I've lost more

than I'm able to count

When all you have is love.

That when you find out what

life is all about.

To gain the most

You must go without

My Thoughts

"HARD times often lead to the GREATEST moments of your life. Tough situations BUILDD strong people."

Hard Times

Experience is

the best teacher.

Never talking during the test.

They will compliment you on

your strengths in order to

find your weakness.

Out work the rest

then rest under money trees.

If money did grow on trees

What would your favorite

season be?

Fall so, money would fall

all over me.

A shower of dollars

exotic dancer mentality.

People say I'm cheap.

I would say

I'm being frugal.

Being naked is embarrassing.

Being broke is brutal.

I remember we was so broke,

it was hard for me to even

pay attention.

We was so poor growing up

we couldn't afford

hamburger helper.

Instead we ate beef assistant.

You ever been so broke,

you just ate sleep for dinner?

I'd rather be broke

with a good heart,

than rich

with bad intentions.

It's like we are

searching for answer

but the question

marks are missing.

Buried deep within your

mind. Closed off,

an area that remains hidden.

Like a galaxy with no stars

Like a boat with no water.

Like having a car and no gas.

Like a son with no father.

Stuck somewhere between

try hard and go harder.

Try harder and go farther.

Overwhelming,

we throw the towel in

and give up like why bother.

Remember times you felt

rich touching your first

hundred dollars.

They say money

can't buy happiness,

and the best things

in life are free.

Like laughter, love,

friends, family, smiles, hugs,

kisses, and sleep.

Materialism is stupidity

buying things

we don't even need.

With money we don't have

to impress people

we don't see.

Going to Walmart for one thing, leaving with things you don't need.

Keeping up with the Jones's looking over the fence.

With all this new stuff reminiscing on where all the time went.

Being broke

is part of the game

but staying broke is personal.

Being broke

don't make you lame.

Being rich

don't make you real.

Being homeless is something

I can't live with.

If you hang around nine

broke people

you will likely be the tenth.

When you are broke

nothing at all is funny.

When I say broke,

I'm not saying,

I don't have any money.

Bill collectors

and don't mind taking

chunks from me.

When you are broke.

Not much is funny.

I just hate when I have too

much month at

the end of my money.

My Thoughts

"Our PRAYERS should be for BLESSINGS in general, for GOD knows BEST what is GOOD for us."

Captive Prayers

Have you ever

heard a slave pray?

Imagine what would

a slave would say.

Dear Lord,

give me the strength

to get through the day.

In a crazy way,

I appreciate everything

master has done for me.

I'm a man I know there is

more out there for me.

I taught myself to read,

I read the bible every day.

They whipped the native

language from my father,

This is all I have left to say.

They treat their dog better

than they do me.

What have I done

to deserve this.

My brother once

said we should run.

What could be better than

what we have here?

It's like the faster I run,

the more I remain still.

An endless race

like running a marathon

on a treadmill.

History repeats itself,

Going in circles like a

hamster wheel.

What is freedom?

My Thoughts

"I don't DREAM at night; LIFE has given me the stuff I NEED to be able to dream during the day. I'm BLESSED."

Daydream

I'm stuck between a rock

and a hard place

Between the stars

and the ground.

I just got off a plane

before I came

So I'm closer to the stars

right now.

I'm somewhere in the clouds

I'm on the brink

of a thunderstorm.

She cries on my shoulder

flash floods,

more like a rainstorm.

The tears fill an ocean

I try but I can't transform

Introverted, I'm silent.

On the radar a quiet storm

On this platform,

in rare form.

Let it sink in.

Let me brainstorm.

From the outside looking in,

My mind wonders.

People have a lot to say

Walk a day in my shoes

Is it the right way?

Lately life's been so crazy.

So, I pray. Will it help me?

You can't replace

prayer with being lazy.

Lazy with ambition.

Ambition with mission.

Insecurities with confidence.

When god has something in store, he makes life stressful and uncomfortable.

When god has something in store, he will make sure everything is affordable.

When god has something in store for you it's not always a brand-new convertible.

Great things only come to those who hustle.

Great things come in the form of those who loves you.

What is love?

God is love

Where is Love?

Nothing to be seen.

God loves you.

It's not above you.

God is in you.

After all we been through.

A lesson I've learned is

you can't make them love.

It's something you feel

Careful once you fallen.

Now you are in deep.

Free falling, faster

A feeling that lasts.

They say the key to love

is laughter.

So smiles like it is your last.

My Thoughts

"Just say No to drugs."

Base Rock

Product of the eighties

god saved me,

I'm just a baby.

Crack up in my system,

never sold base rock.

I lived in a crack spot

Every time the door knock.

My heart stopped,

that's when the beat drop.

I had it in my system,

it made it hard to listen.

The drip steady glisten

In exchange for prison.

How to whip up hard?.

That's what my wrist says.

Many didn't have a choice,

so they chose the hard away.

If you are slanging rock

talk about the harder days.

If you are slanging rock

Save for that fed case.

It's a dirty game today

yet we still choose to play.

North side swerving lanes

Kush in my main veins.

The sixth floor six times

never dropped a name.

Can't knock the hustle

get green by any means.

If I wasn't slanging words

I'd be serving feins.

My Thoughts

"I think it's TIME we kill for our women, be REAL to our women, try to HEAL our women…"

H.E.R.

Once upon a time

there was a girl

her name was heather.

She would rather

Play outside in the rain

She has fun alone,

in stormy weather.

Her mom was white

and her dad was black

so she never learned

to get her hair together.

Feeling inferior from what

she sees in reflection

of her own mirror.

No matter

how hard she cleaned

it never got any clearer.

Her parents split up when

she was young,

Uncontrollable tears.

She was split

between the two homes.

Unsolved fears.

Parents always working to

provide which left her at

home alone.

Unsupervised years.

She looks in the mirror and

She question what she sees.

She tries to

reaffirm her beauty.

She just can't make herself

believe her dad told her she

was a princess.

What kind of king

would just leave.

So she stares

into her existence

And she reflects

and she grieves.

She's not connected

with the source,

she falls to her knees.

She's just hoping for

assistance.

Hoping more for a blessing.

She begs she pleads

She just wants to talk

for someone

to listen, to witness.

someone to fix this.

The kids at school are cruel.

It's hard for her to learn

When every day

she must fight.

Bullying

should be a major concern.

Often bullies are face with

the most horrible situation.

A negative cycle, they don't

know how to face it.

Depression is real

so many straddles the line.

Every day after school,

by herself

in her mirror she cries.

Smiling through the pain,

she tries to be strong.

They ask how she is doing

She struggles and says

"Alright!"

As a result,

she's always angry.

Emotions running wild.

Which makes it hard for her

to focus.

Always fighting,

her mind racing.

She doesn't know

how to cope.

She starts hanging out

with the wrong crowd.

That's how she got

introduced to dope.

Changes happening

on the inside.

Her own mom

doesn't even know.

The lack of communication

between the two

are the reasons she didn't

know that she smokes.

Her mother says,

know your value.

All she thinks about is

does her attention cost.

Like how much it would

hurt you honestly.

Just to take just one day off.

All girls want to do is talk.

She was lost in the sauce.

Confused in her decisions.

She looks in the mirror.

Reflections diminished

Dirty from the insecurities,

mistakes driven by her fears.

Mere thoughts of history

generate rivers

collecting last night's tears.

Her mother tries to talk to

her in between shifts

but her loving words fell

upon deaf ears.

The stress of a parent trying to keep their children fed, warm and protected. All the same this young girl feels neglected. What went on behind closed doors went on unsuspected.

She fell into situations

where here mind and body

were not respected.

At the point of no return,

he whispered, "I love you."

at that point she felt

connected.

She never even knew

his real name,

The general information

was never collected.

It's too late for questions

now she is expecting

The doctor expresses,

not only is she pregnant,

she is also infected.

Moral of the story

is make sure you mind; body

and soul are protected.

My Thoughts

THANK YOU

FOR YOUR SUPPORT!

www.ingramcontent.com/pod-product-compliance
Lightning Source LLC
Chambersburg PA
CBHW051306220526
45468CB00004B/1228